D0953495

The ZEN of Zelda

Also by Carol Gardner

Bumper Sticker Wisdom

Also by Carol Gardner and Shane Young

Zelda Wisdom

The ZEN of Zelda

Wisdom from the Doggy Lama

Carol Gardner

Photographs by Shane Young

**Andrews McMeel
Publishing**

Kansas City

The Zen of Zelda

03 04 05 06 CTP 10 9 8 7 6

ISBN: 0-7407-2227-1

Fools may laugh at me,
but the wise will understand.

—Lin Chi

INTRODUCTION:

WHEN IT COMES TO DOG-MA . . . WHO BETTER THAN A DOG?

In putting together The Zen of Zelda I had to take a deep look within the dog-mas surrounding my life. This book is an attempt at reflection . . . a reflection of the me in you and the you in me. It is a look at the Zen of my wisdom and the wisdom of my Zen.

What, at first glance, seemed to me obvious wisdom was not. It was wisdom turned inside out that brought out the Zen in me. What was simple was not. What was not, was simple.

In my search for inspiration, I sought truth. But often the truth was not true. And so goes The Zen of Zelda. You must look carefully and closely at the words. And question.

Laughter is at the core of my Zen ... laughing at ourselves brings us closer to enlightenment than anything else. Take time. Listen to quiet. Light a candle or, better yet, set your life on fire by enjoying the humor within. You, too, may find happiness.

— *Almost Zen Master Zelda*

Z

Dog-mas

When making choices in life ...
do not neglect to live.

Look at what appears to be impossible ...
then change your beliefs.

Every obstacle is an opportunity.

The last to discover the water
will be the fish.

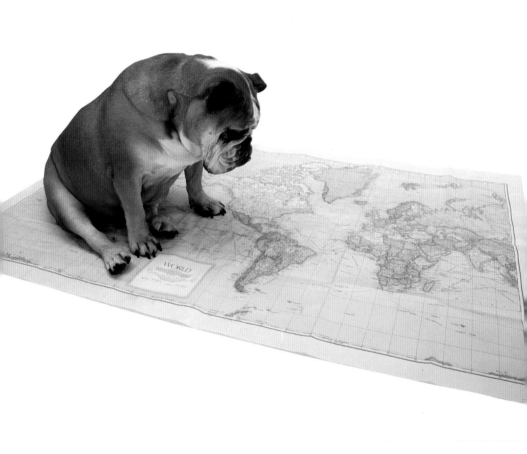

Each place along the way is somewhere you had to be, to be there.

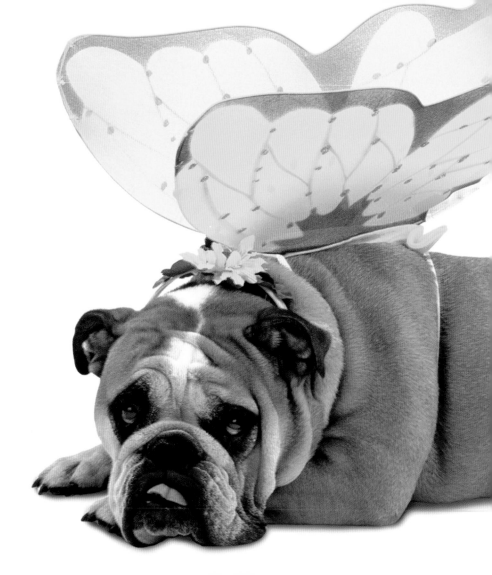

Zelda dreamed she was a butterfly. Or was it the butterfly that dreamed it was Zelda?

Do not seek to follow
in the footsteps of the wise.
Seek what they sought.

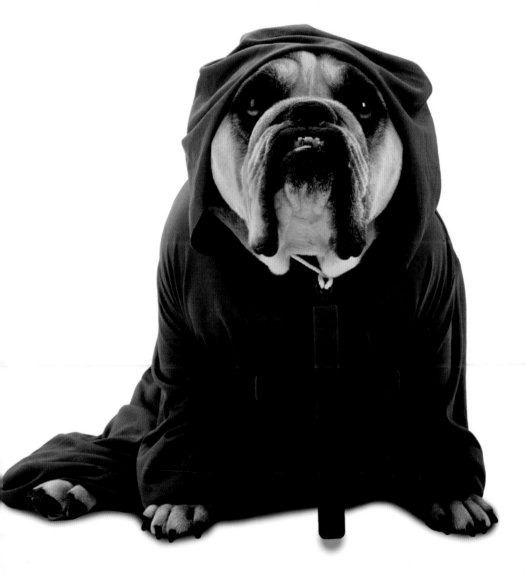

Live the life you imagined.

If you wish to drown, do not torture yourself with shallow water.

The only limits we have
are the limits we believe.

Conflict cannot survive without you.

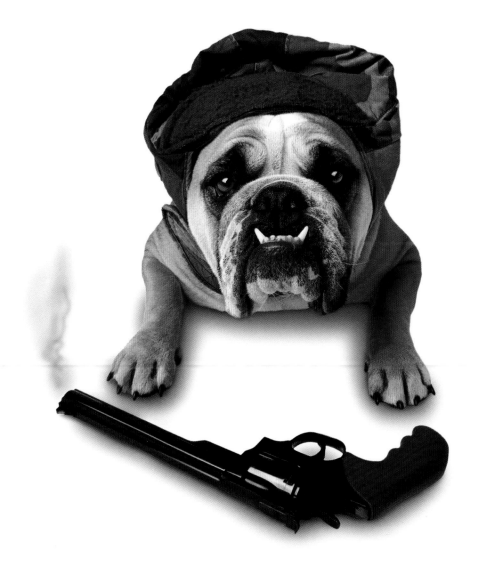

You are a soul with a body ...
not a body with a soul.

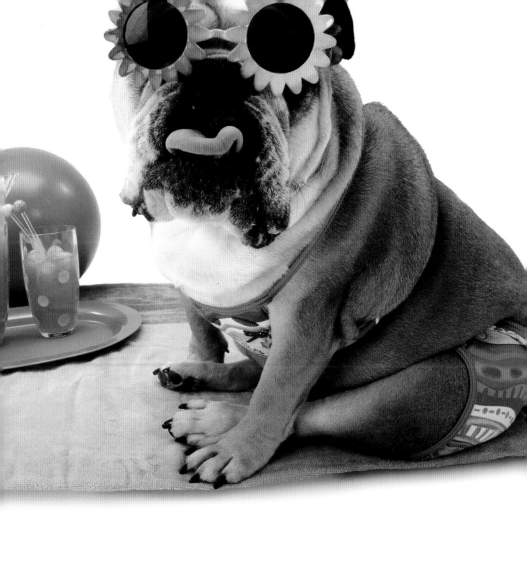

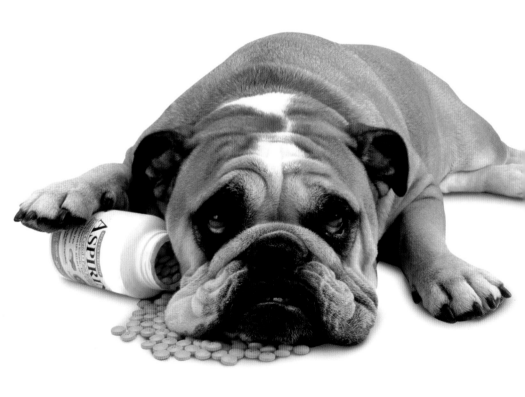

There is no stress in the world,
only people thinking stressful thoughts.

A ship in a harbor is safe, but that's not why ships are built.

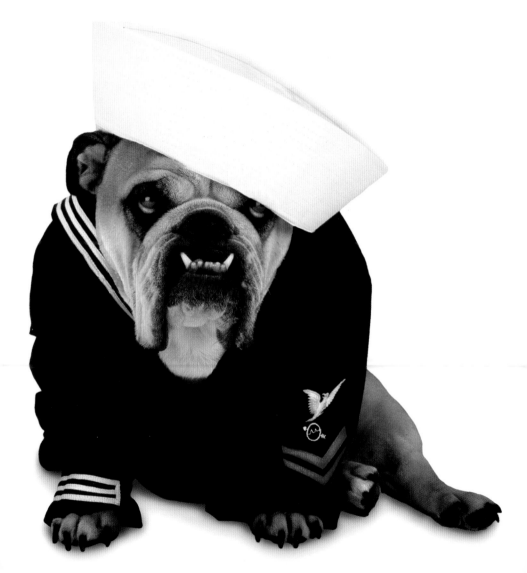

Embrace the perfection of
conscious nothingness.

If you pursue appearances,
you overlook the primal source.

What you have become is the result
of what you have thought.

Always remember you are unique . . .
like everyone else.

Truths

Don't sweat the petty things,
and don't pet the sweaty things.

If an event happens, it cannot unhappen.

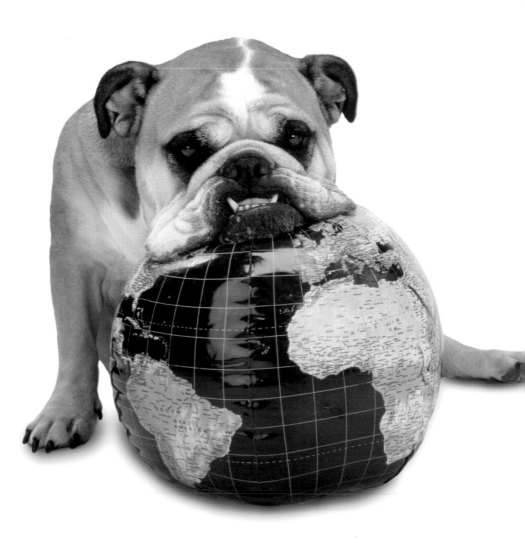

How can you choose sides
on a round planet?

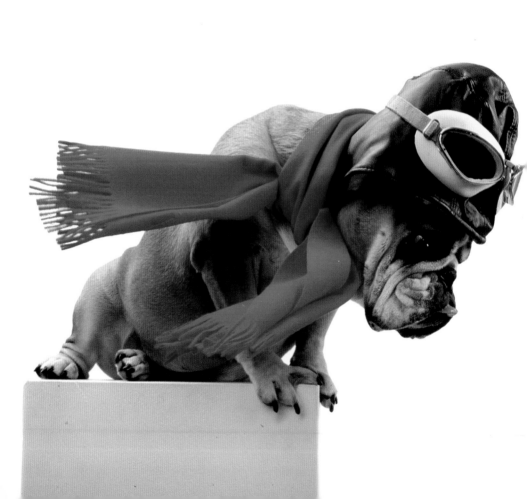

Leap . . . and a net will appear.

It is said that aerodynamically bees aren't supposed to fly. . . .
Fortunately, no one told them.

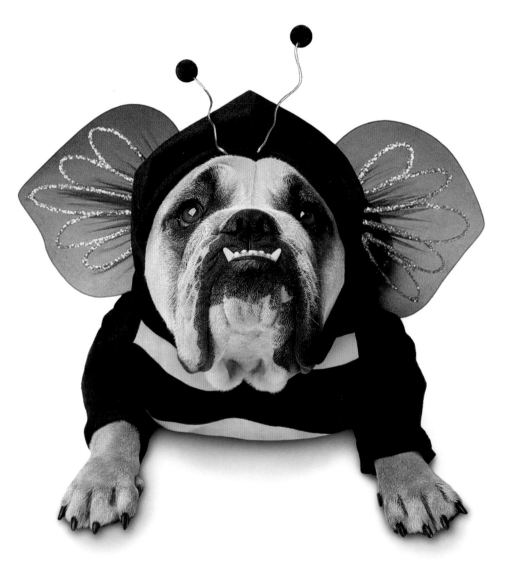

When you can do nothing . . .
what can you do?

If it works anyplace, it works everyplace.

Flowers open without force.

When the many are reduced to one,
to what is the one reduced?

What happens to the hole
when the cheese is gone?

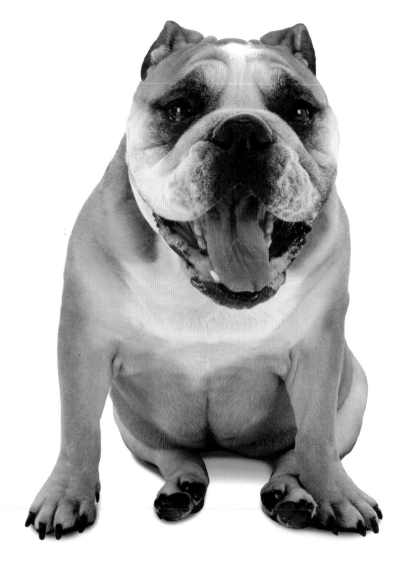

Smile if you want a smile from another face.

There are no such things as strangers,
only friends you haven't met yet.

Love like it's never going to hurt.

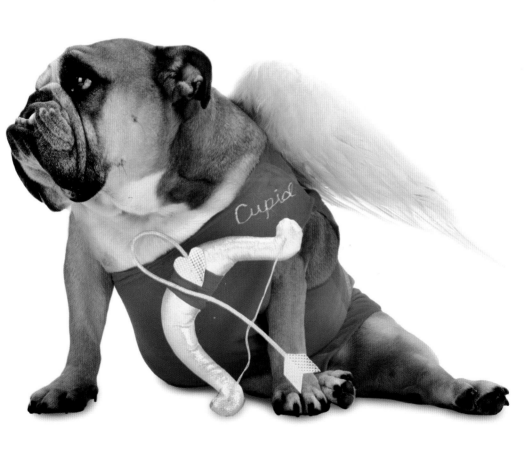

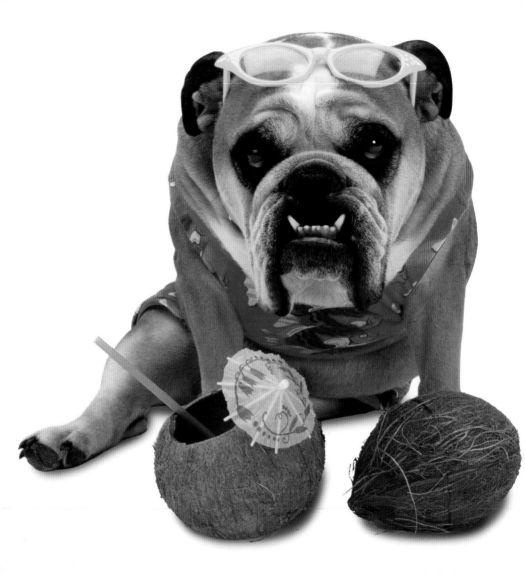

If you assert that things are real
you miss their true reality.

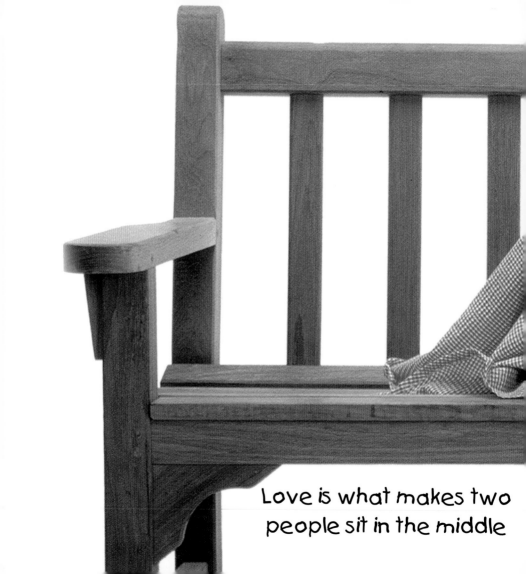

Love is what makes two people sit in the middle

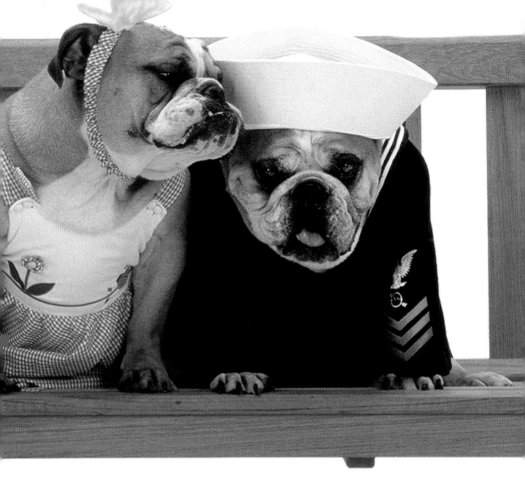

of a bench when there is
plenty of room at both ends.

Fundamentally the marksman
aims at himself.

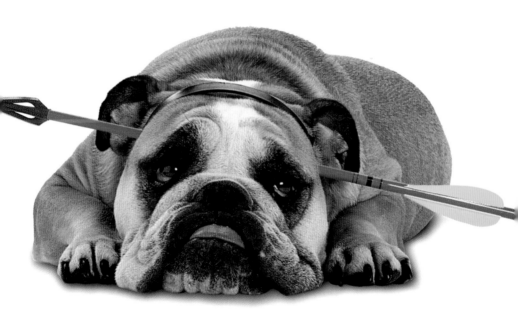

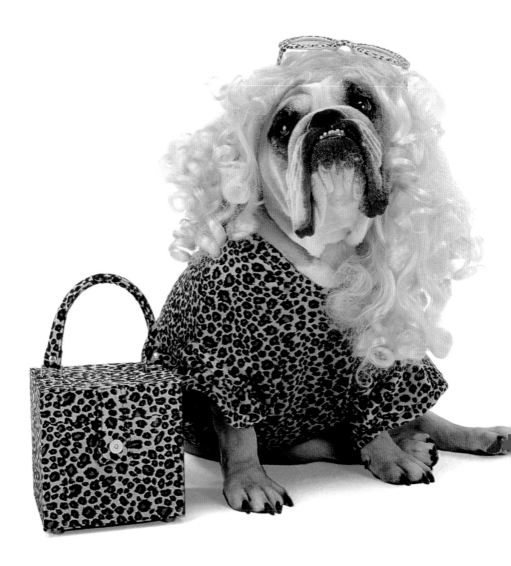

If it is fashionable . . . it is fashion-a-bull.

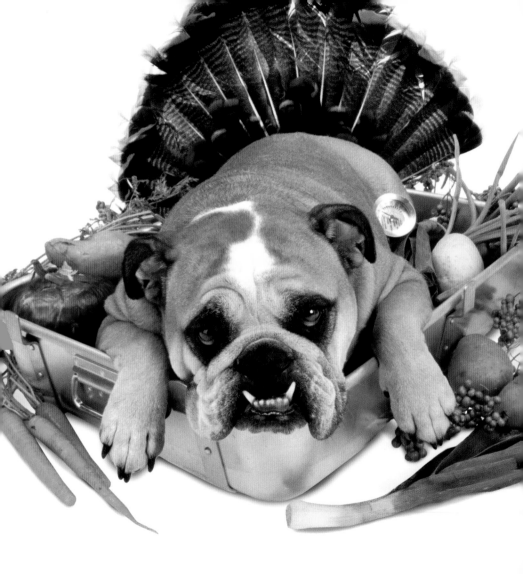

Unless you're the turkey ... be thankful.

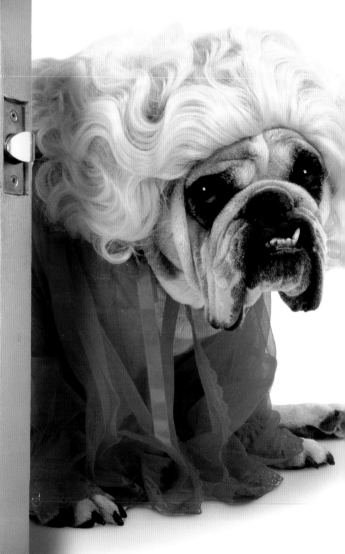

Is your time spent desiring
or is your time spent
taking steps toward desires?

Meditation gives you an opportunity to come to know your invisible self.

Enlightenment

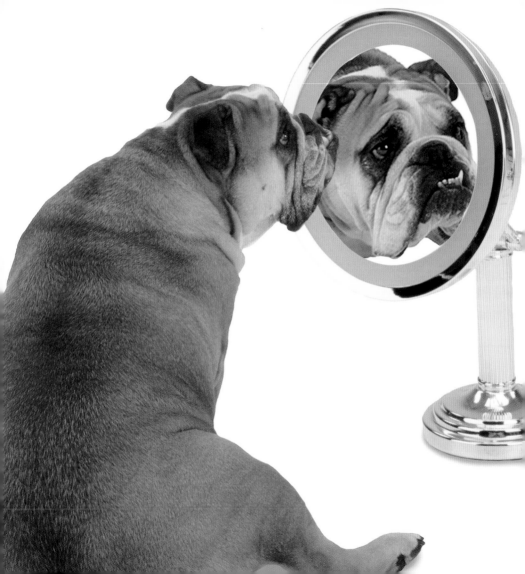

Enlightenment is the quiet acceptance of what is.

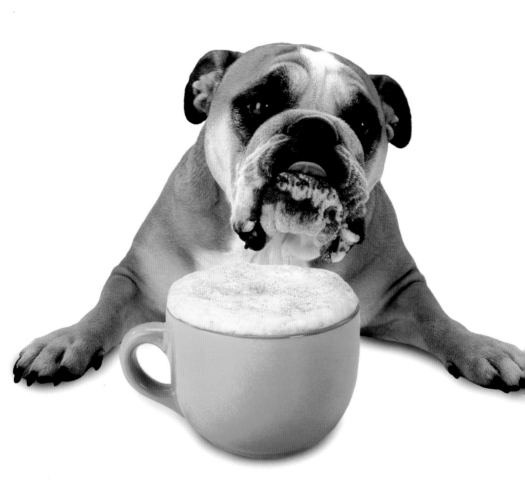

With coffee comes enlightenment.

Time may be a great healer,
but it makes a lousy beautician.

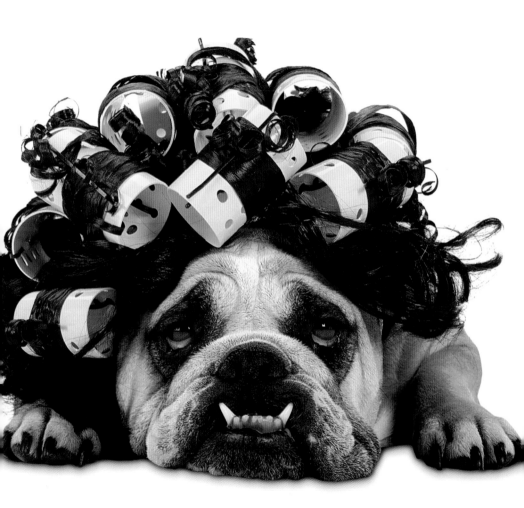

The moment is gone;
it can never be relived.

If you think the world is a dark place,
you are blind to the light
that may illuminate your life.

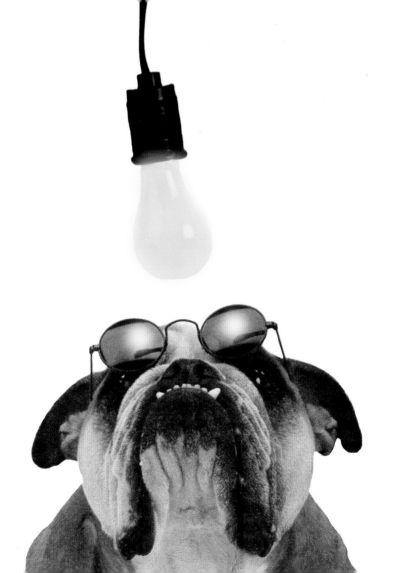

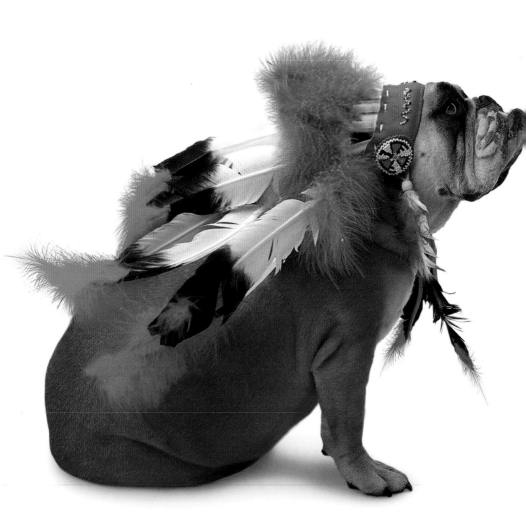

Timing has a lot to do with the
outcome of a rain dance.

De-Nile, De-Nile, De-Nile!

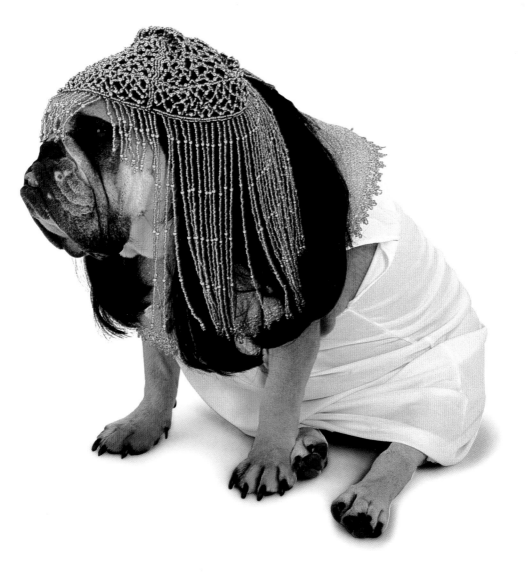

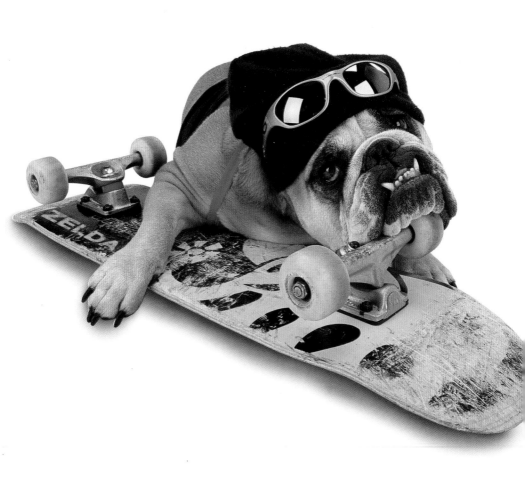

Refuse to let an old person
move into your body.

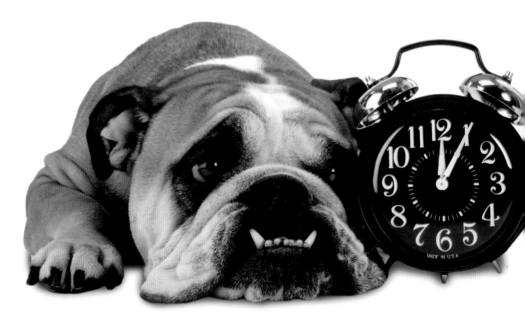

In the context of eternity,
time doesn't matter.

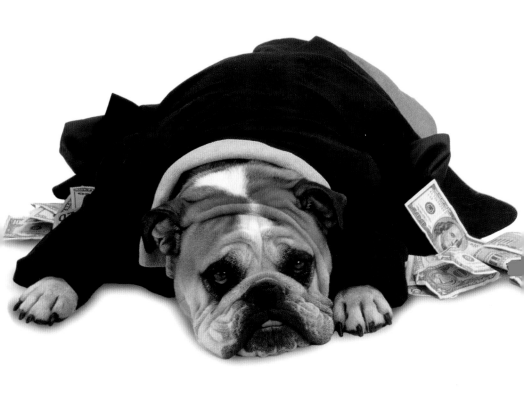

The last jacket you wear
won't need pockets.

The Doggy Lama wishes you
eternal happiness.

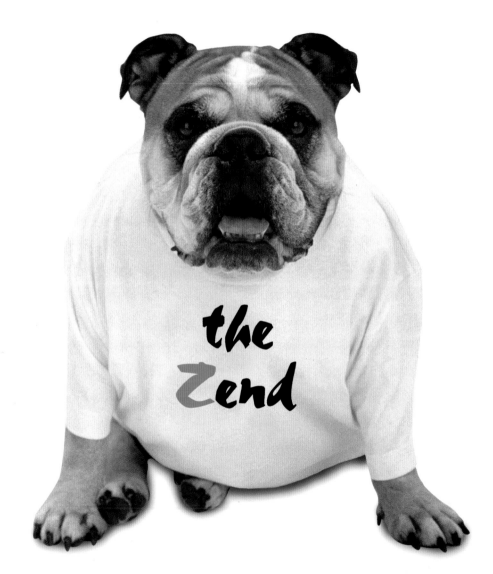